A Keepsake

OAK BLUFFS

ON THE VINEYARD

Arthur P. Richmond

4880 Lower Valley Road • Atglen, PA 19310

To Tony Pane

Thanks is not enough.

INTRODUCTION

Enjoy your visit to Oak Bluffs for years to come with these beautiful images of the town captured through all the seasons. Revisit the paths and walkways as you tour the Campground, Ocean Park, the Carousel, and the many other iconic and historical structures.

Oak Bluffs on Martha's Vineyard is on the northeast side of the island. Being home to the largest marina, Oak Bluffs provides access for ferries and ships from the mainland. The only one of the island's six towns to be consciously designed, and one of the earliest planned residential communities in the United States, Oak Bluffs welcomes visitors from around the world.

The first residents, the Wampanoag people, lived here perhaps earlier than 10,000 years ago. The first Europeans arrived in the 1640s, and this area was originally a part of Edgartown. In the 1830s, the area became popular for Methodist revival meetings. In the beginning the meetings were tent-based. As they became more popular and people stayed longer, the Campground gained its quintessential Victorian cottages, built in the 1860s and 1870s.

In 1880, the area containing the Campground and the resort was separated from Edgartown and was incorporated as Cottage City. Reincorporated in 1907 as Oak Bluffs, the town's popularity boomed with its coastal location. Now, more than 100 years later, Oak Bluffs offers idyllic vacations, romantic hideaways, and seaside vistas.

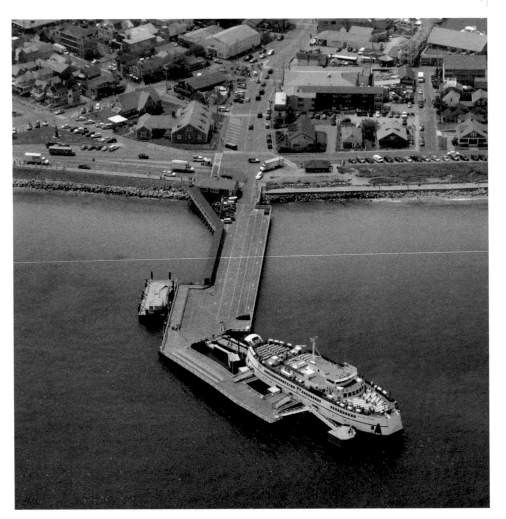

An aerial view of one of the ferry docks.

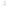

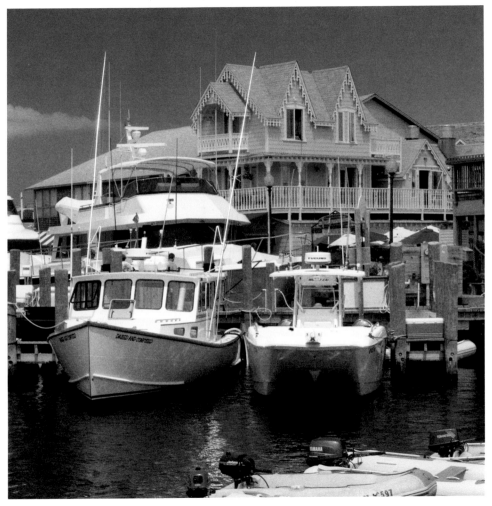

Boats docked in the harbor.

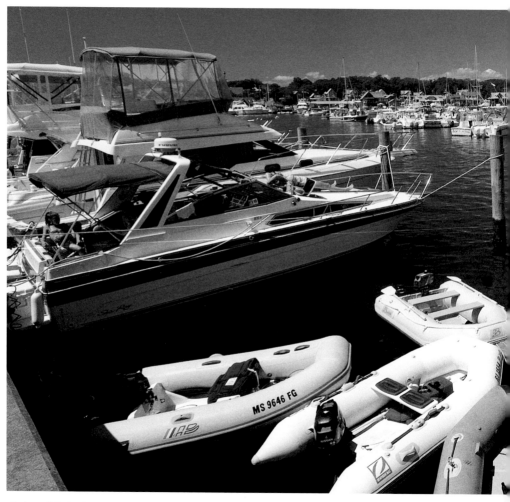

A view of the harbor.

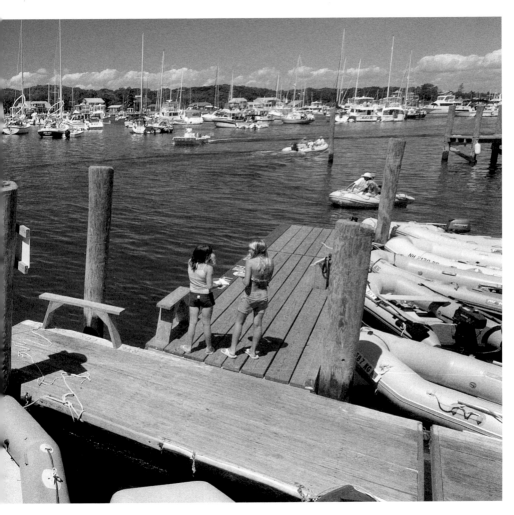

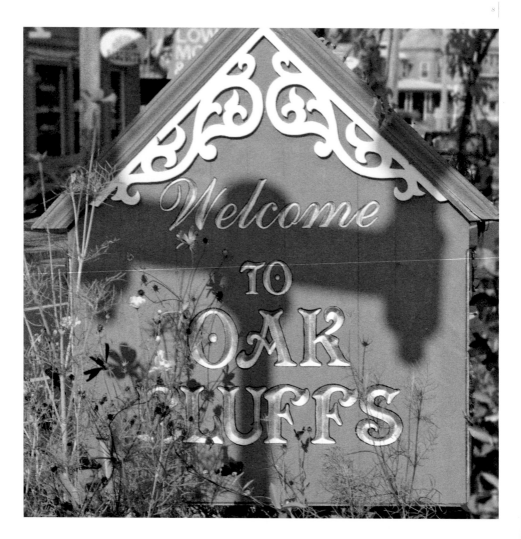

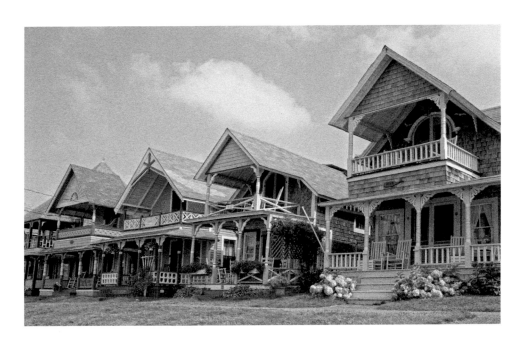

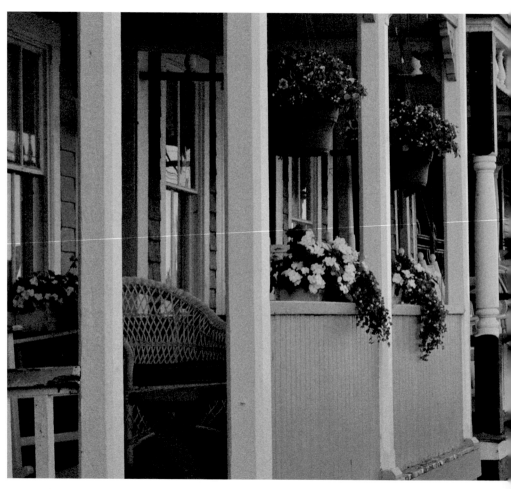

Cottages line Lake Street, with the Wesley Hotel at the end.

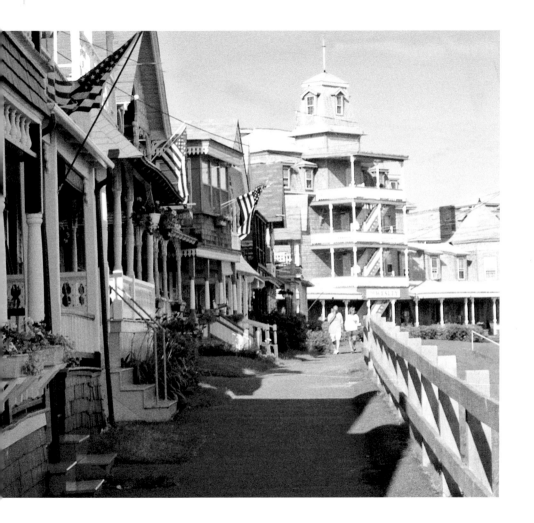

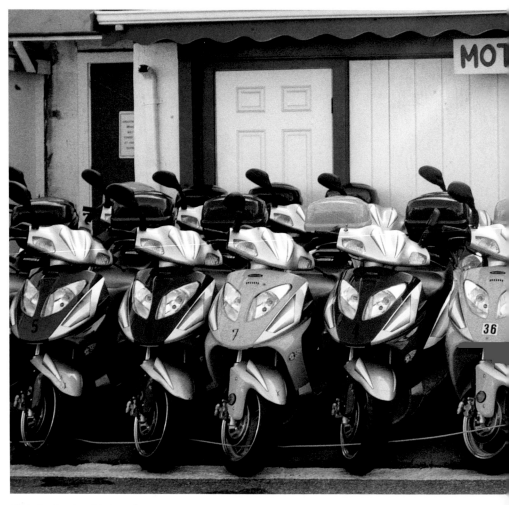

Mopeds allow tourists to explore.

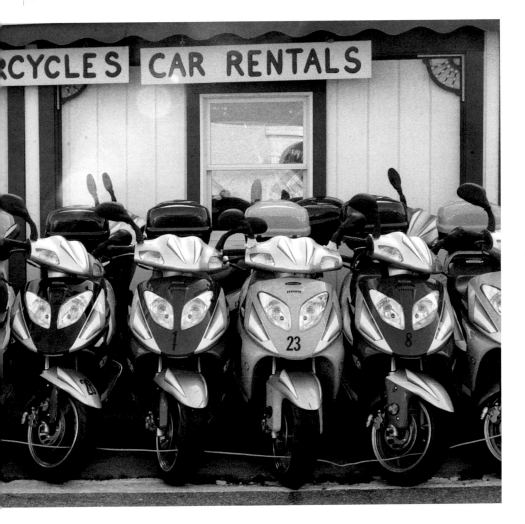

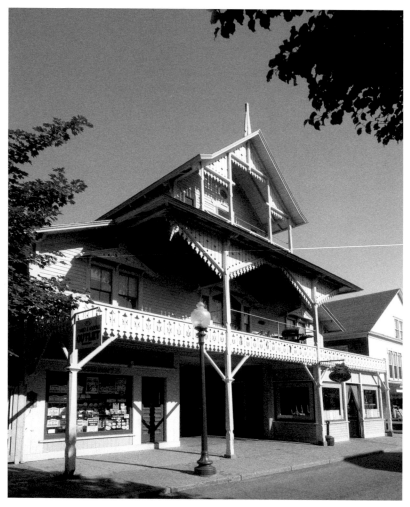

The Arcade on Circuit Avenue.

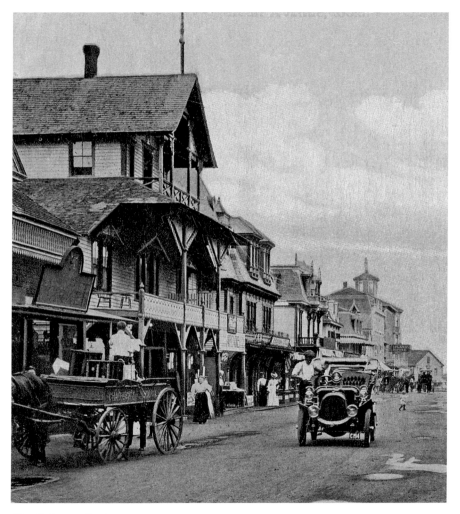

Circuit Avenue of yesteryear.

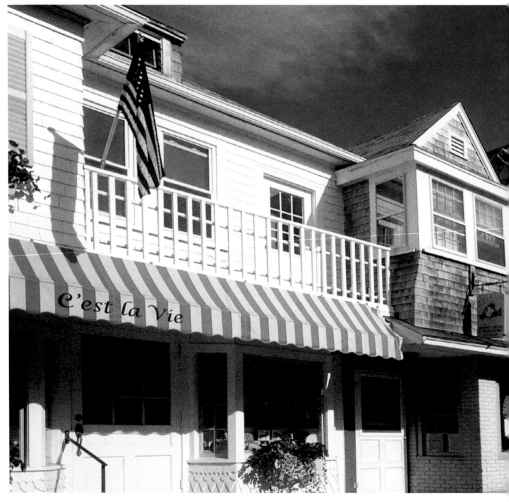

Circuit Avenue today.

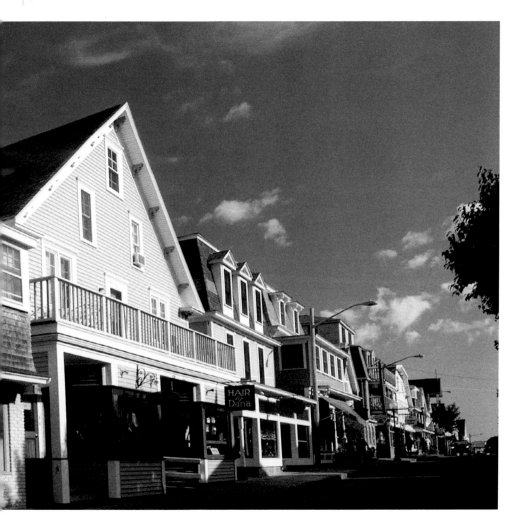

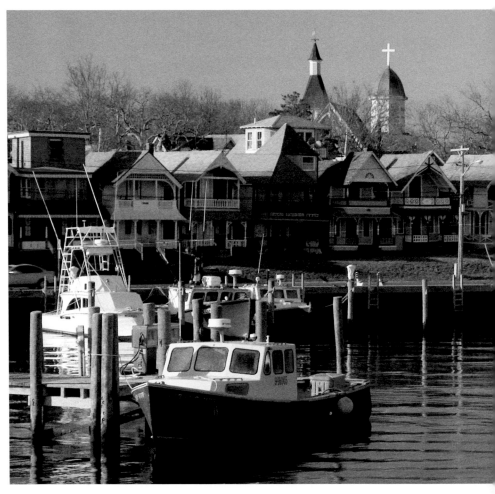

The harbor is almost empty off season.

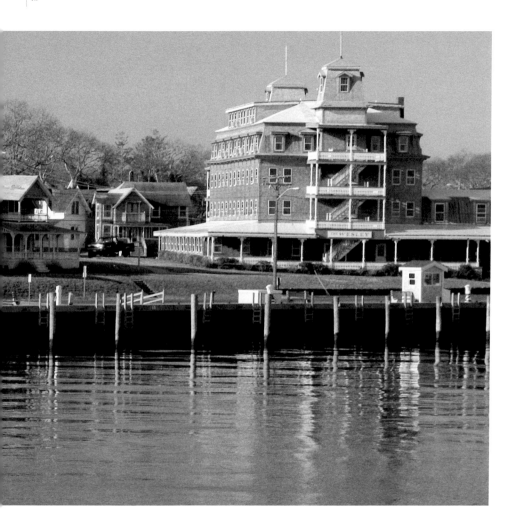

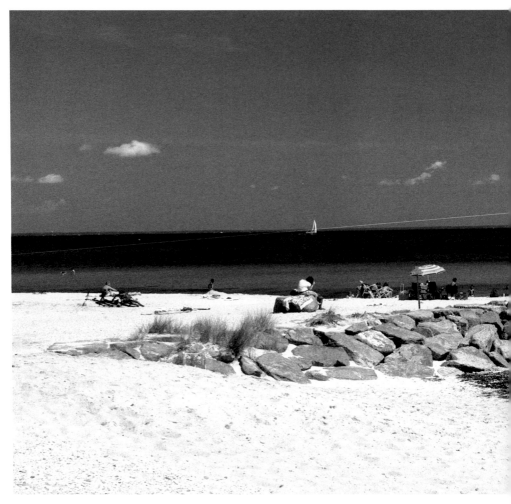

Sandy beaches are close to town.

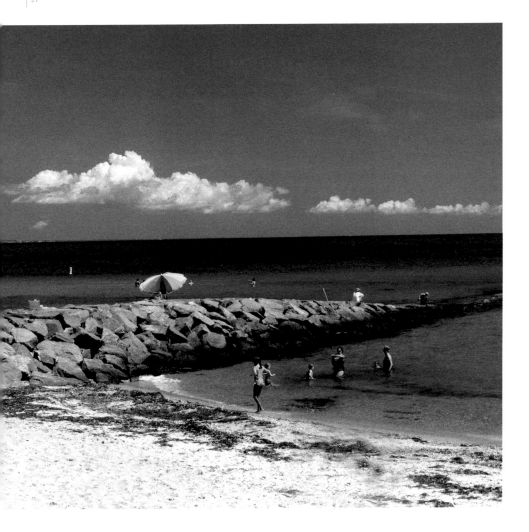

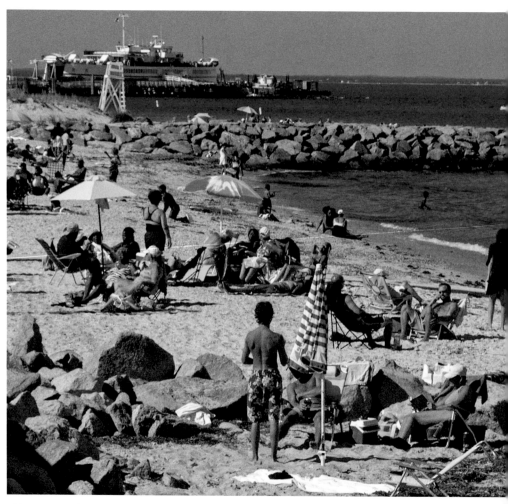

A busy summer day at one of the many public beaches.

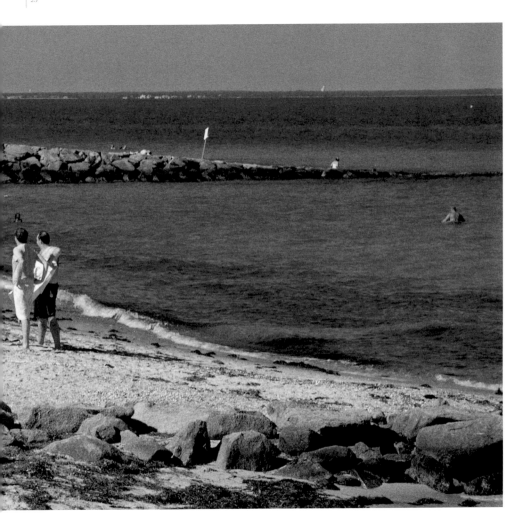

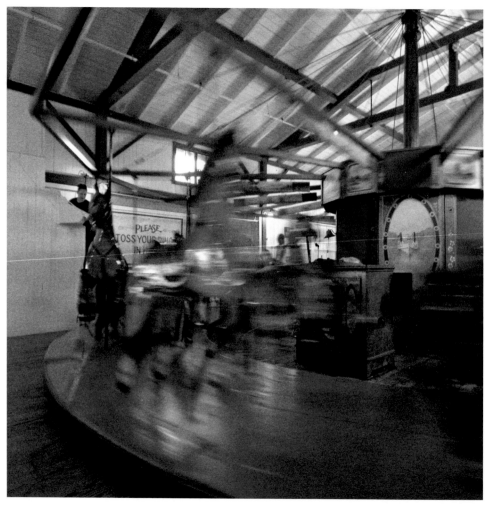

The Carousel arrived in 1874.

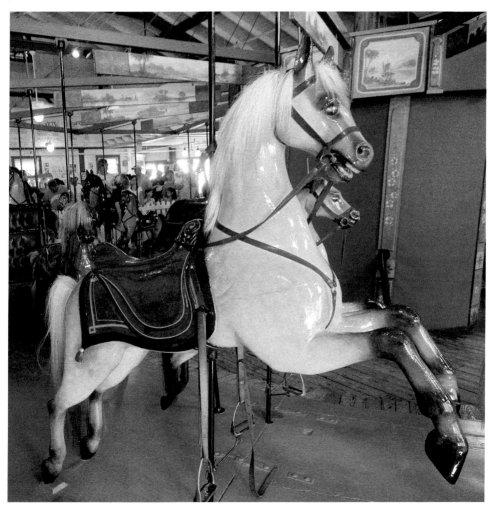

Riders can choose a prancing horse or a dragon seat.

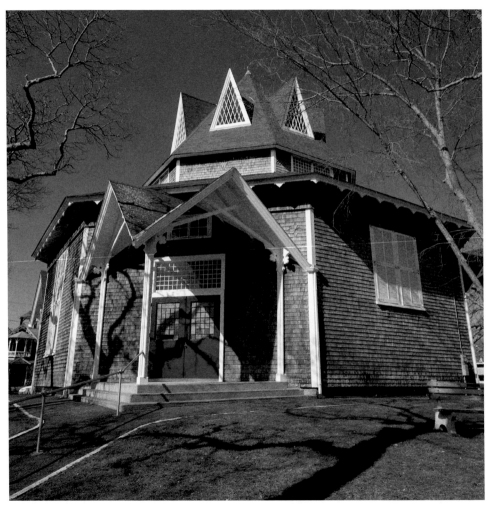

Union Chapel.

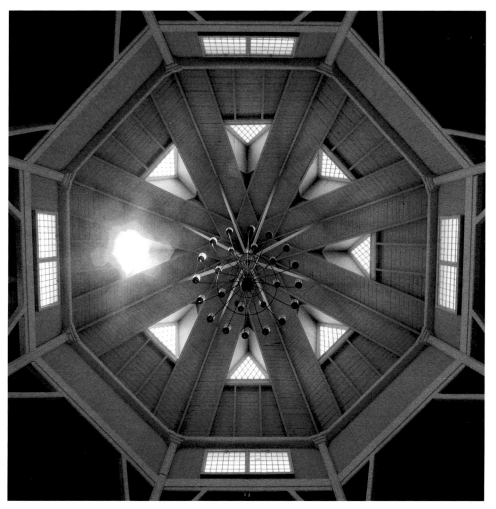

The brightly colored dome inside the chapel.

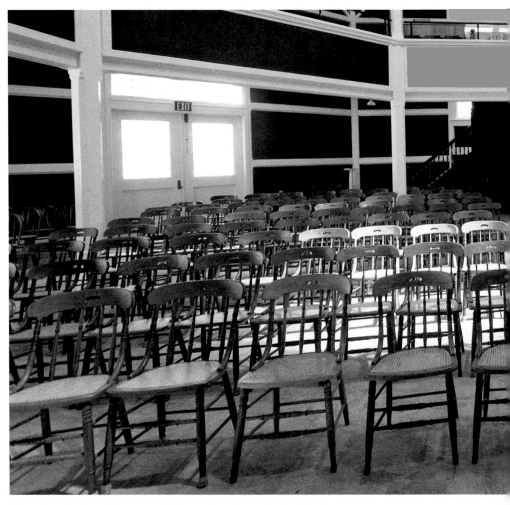

The antique chairs can be rearranged for a variety of events in the chapel.

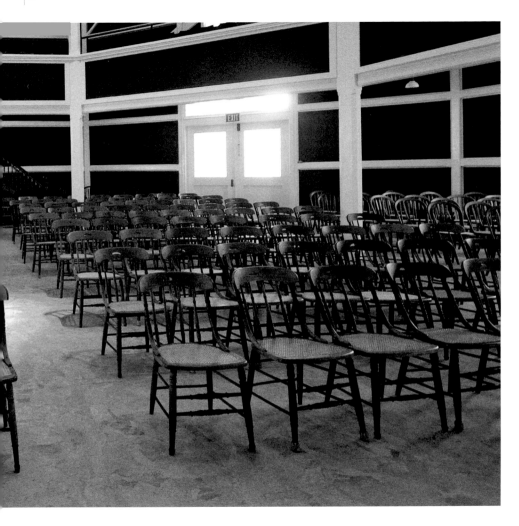

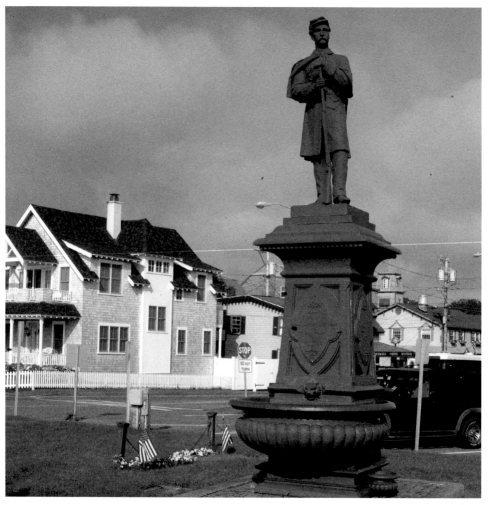

The Civil War statue is in Ocean Park.

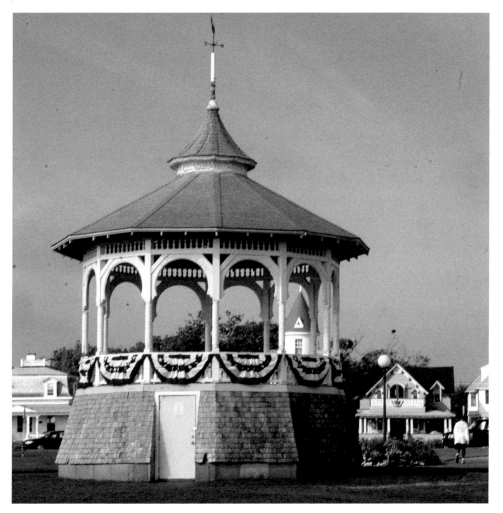

The Ocean Park bandstand.

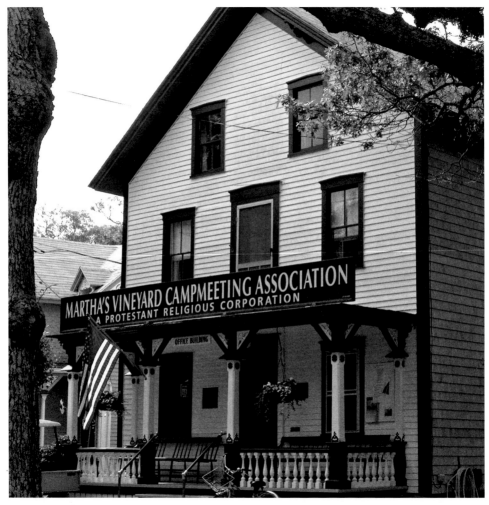

The Association office.

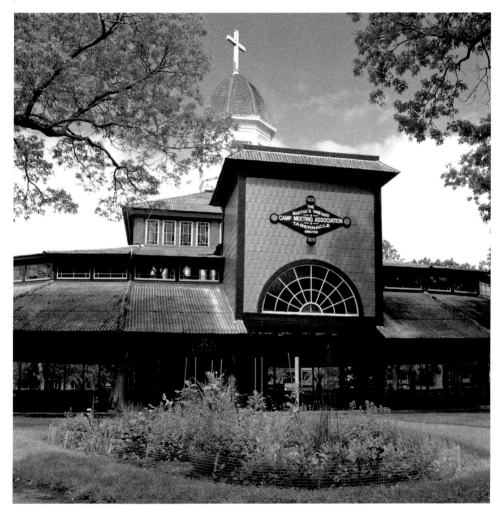

The Tabernacle, the focal point of the Campground.

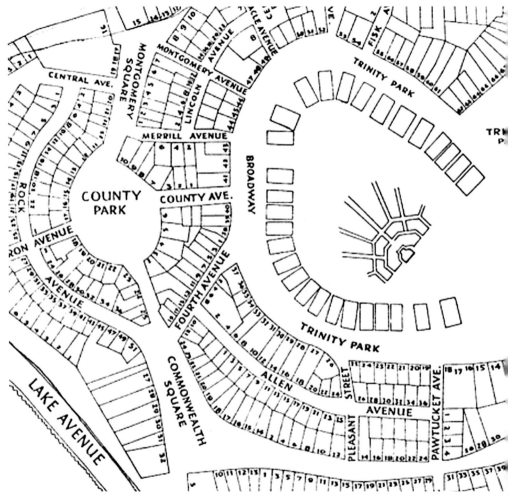

An 1875 plan of the Campground.

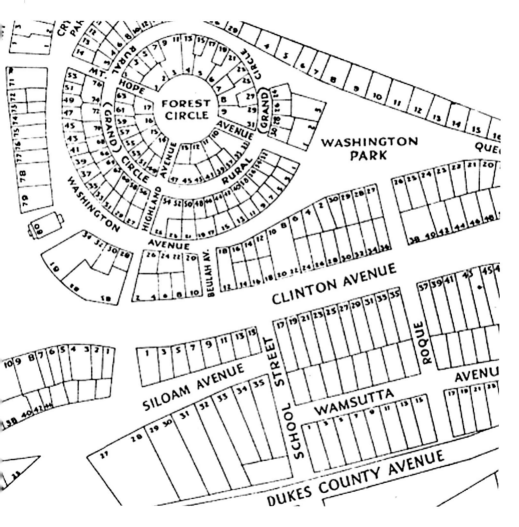

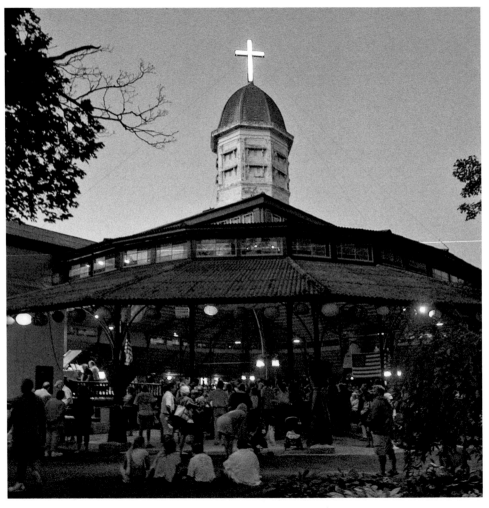

During the summer, the Tabernacle hosts a variety of events.

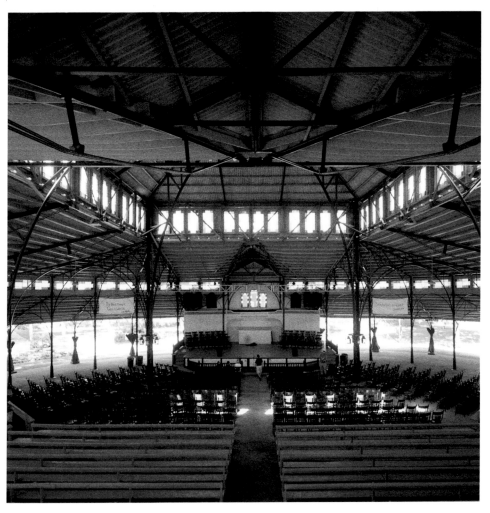

The interior of the Tabernacle.

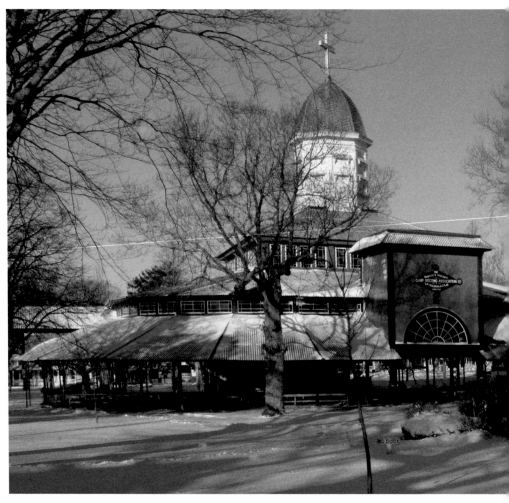

A recent snow covers the grounds.

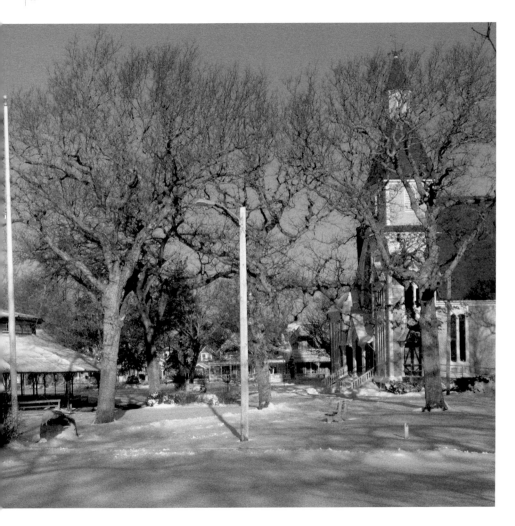

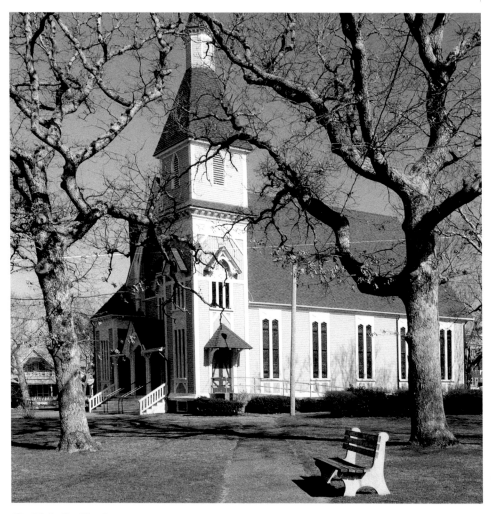

The Methodist Church.

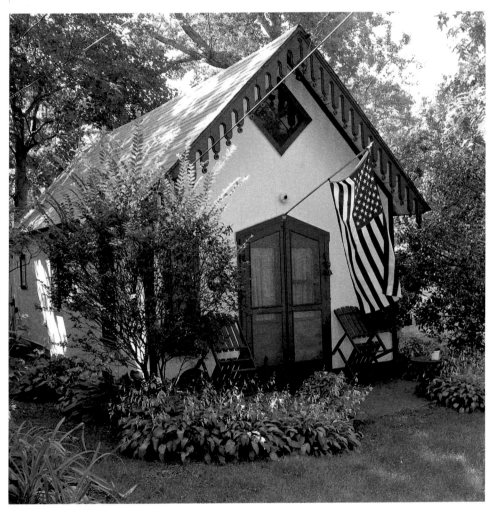

One of the smallest cottages in the Campground.

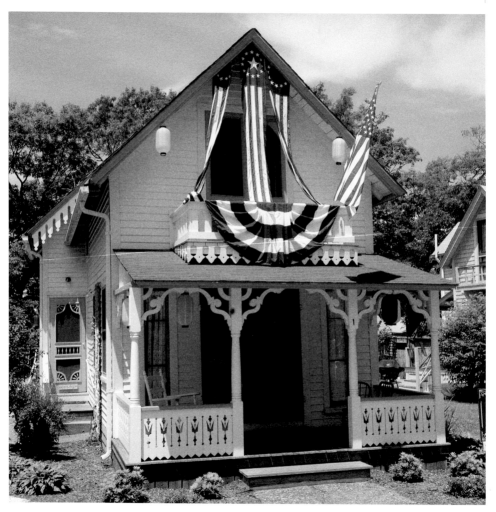

The Cottage Museum is open for visitors.

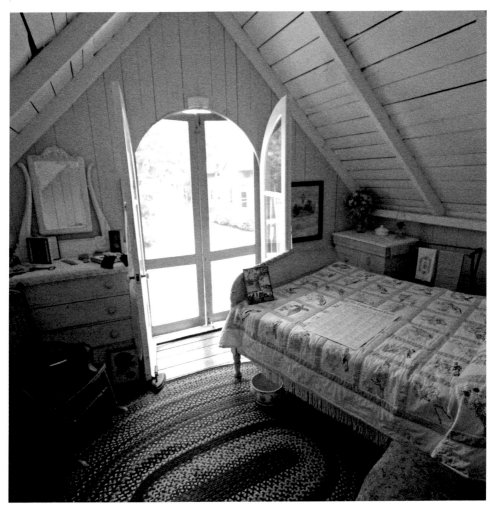

The front bedroom on the museum's second floor.

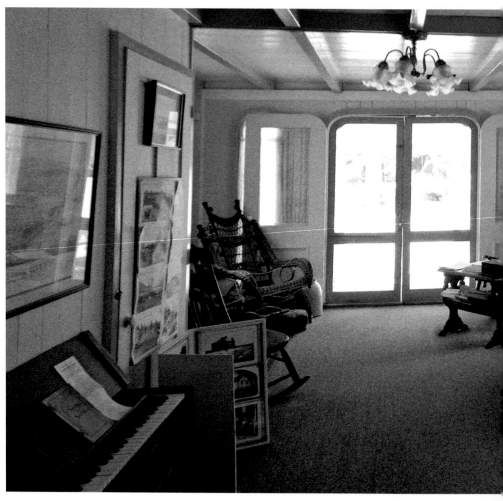

A typical cottage living room can be seen in the museum.

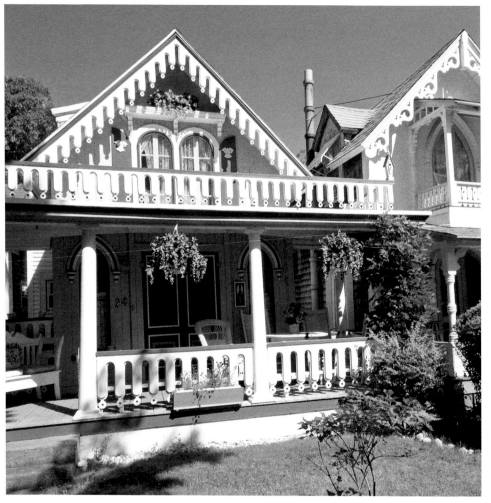

A decorated cottage near the Tabernacle.

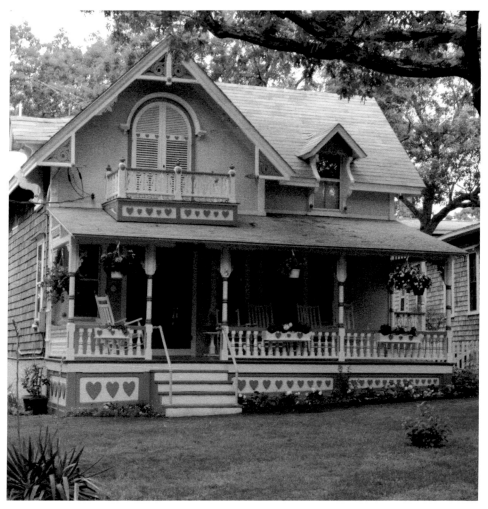

The Heart House.

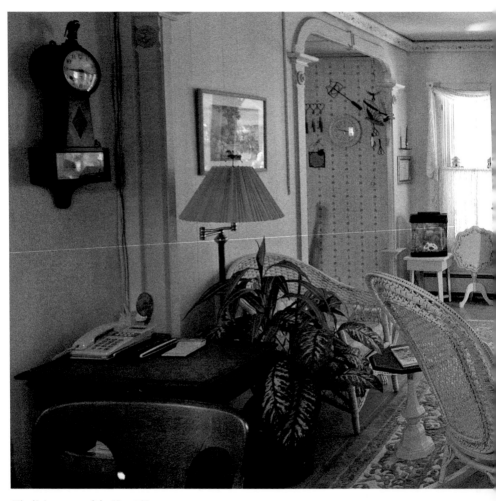

The living room of the Heart House.

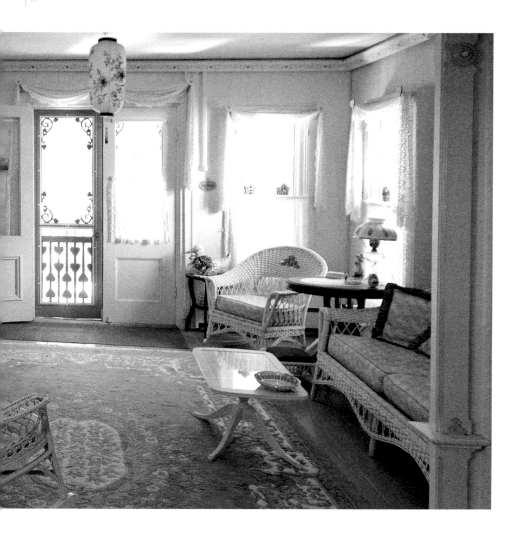

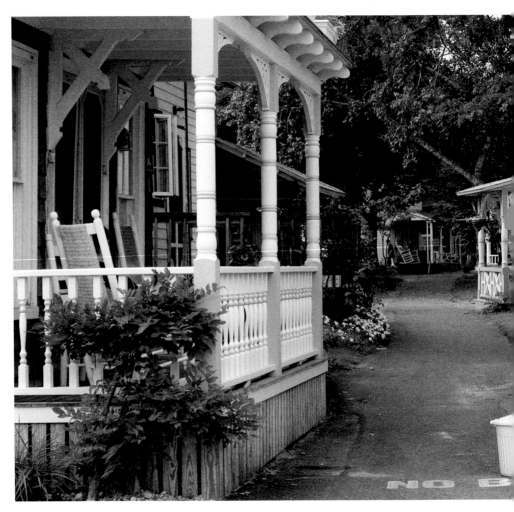

Many of the pathways are for walking only.

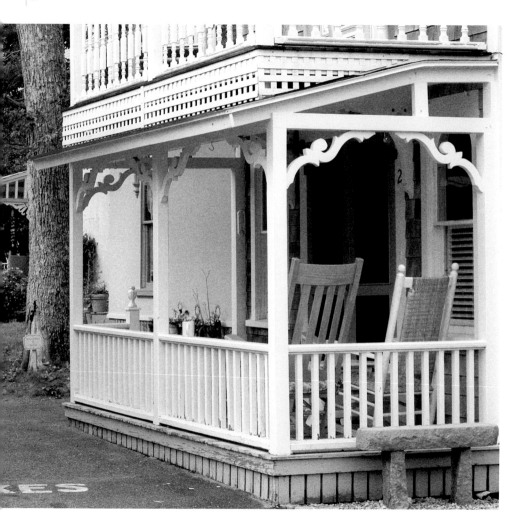

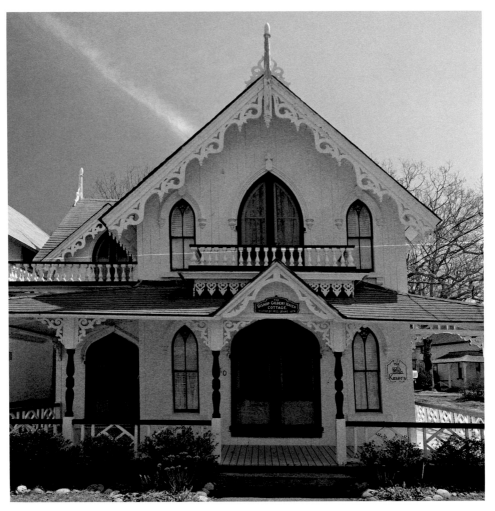

President Grant visited this cottage in 1874.

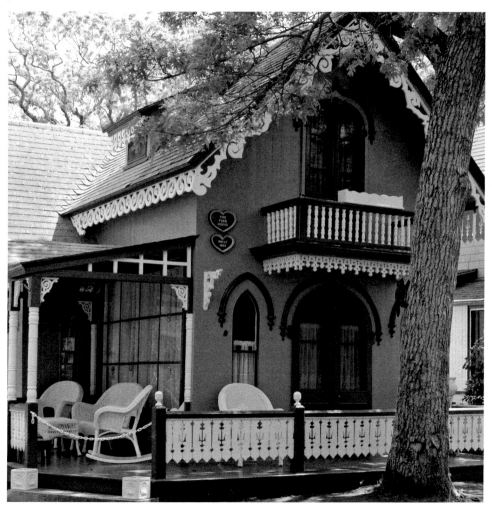

The pink cottage is very distinctive.

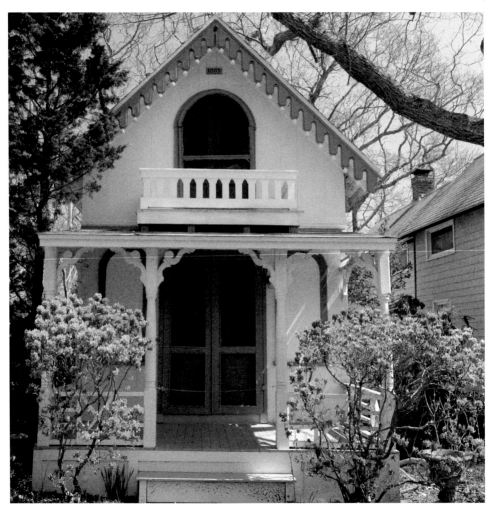

A brightly colored cottage in spring.

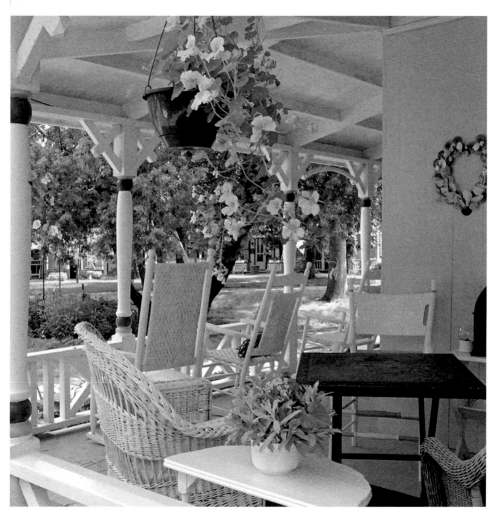

This porch overlooks a quiet park.

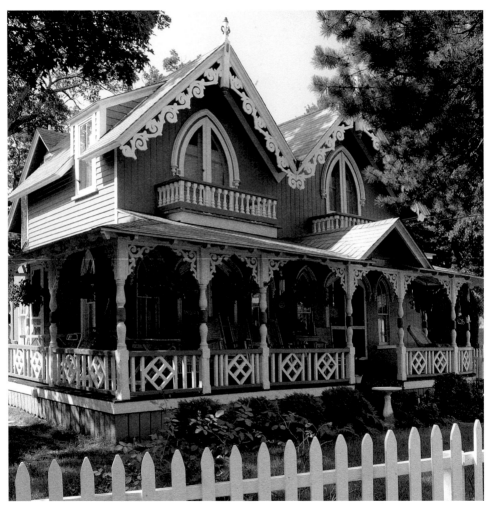

Summer or winter, a quintessential cottage.

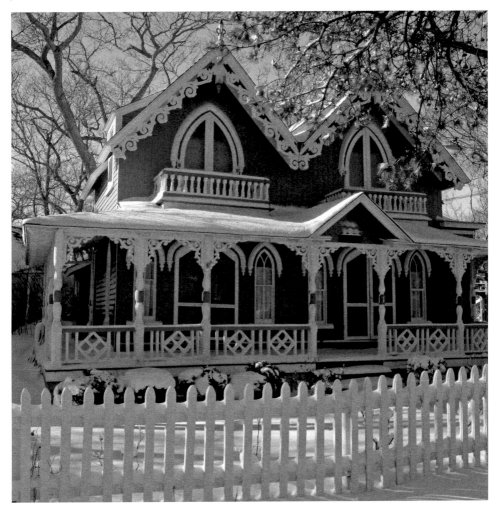

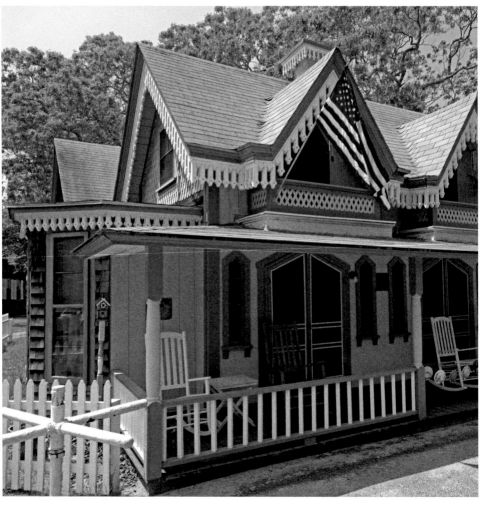

The Lawton Cottage is one of the oldest in the Campground.

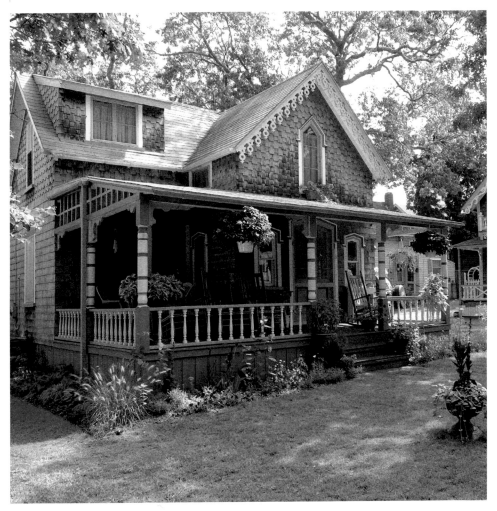

Larger cottages are farther away from the Tabernacle.

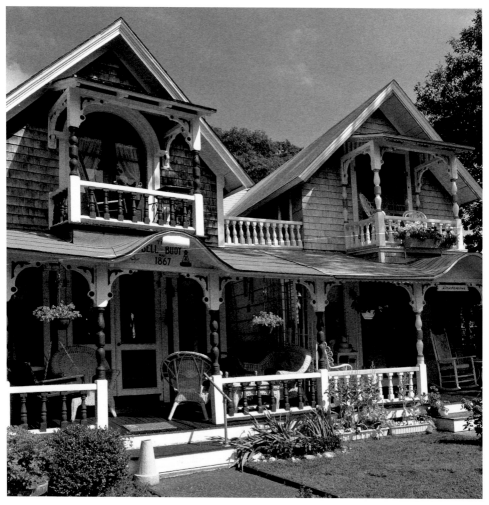

Cottages are closely connected.

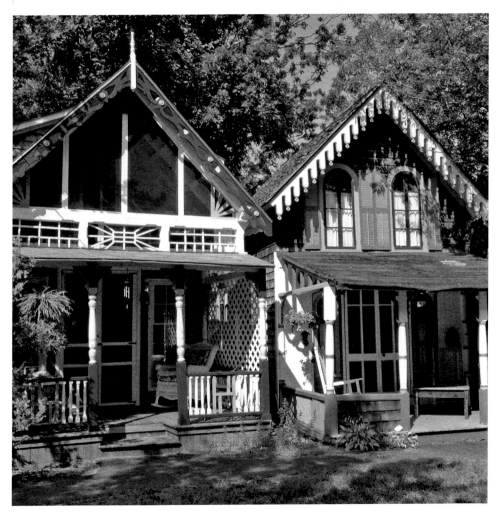

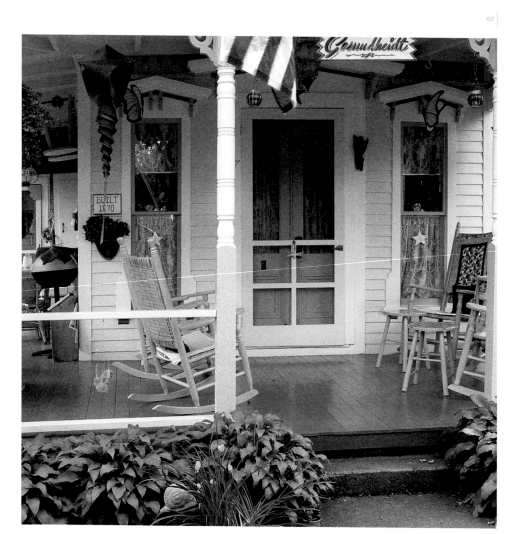

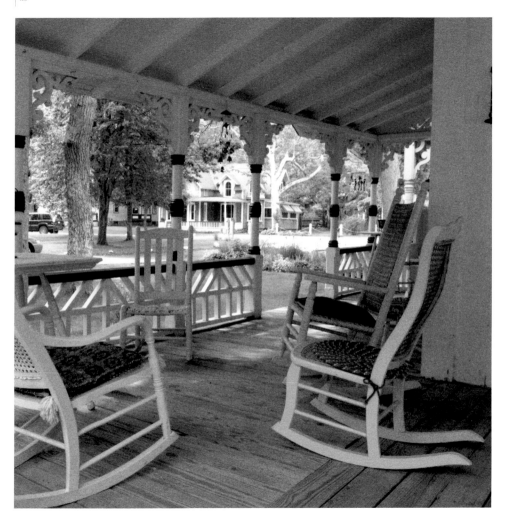

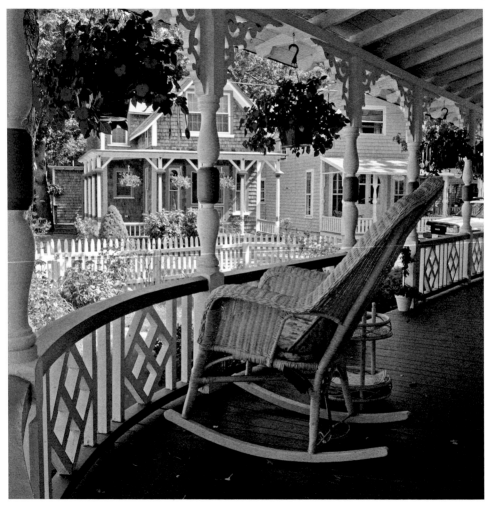

In early times, porches were used to greet guests.

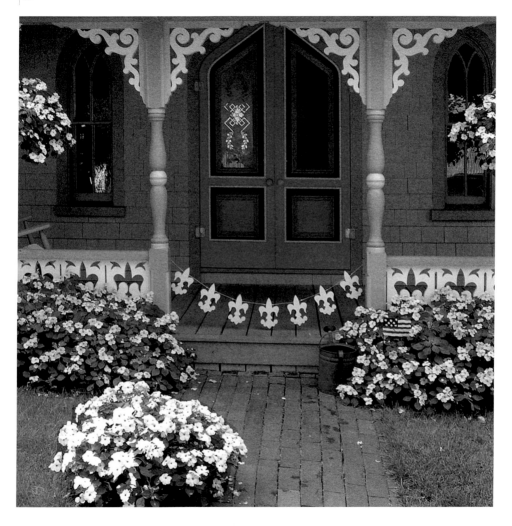

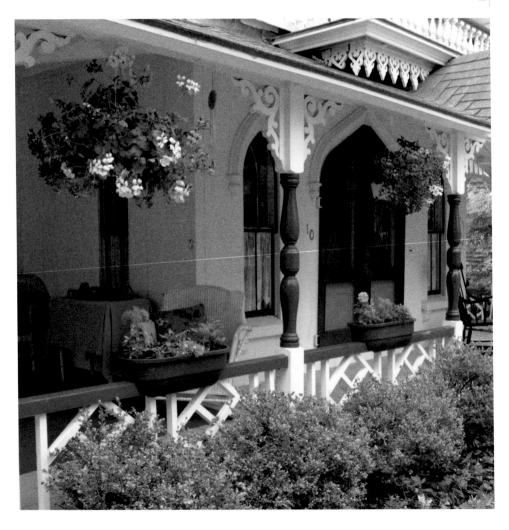

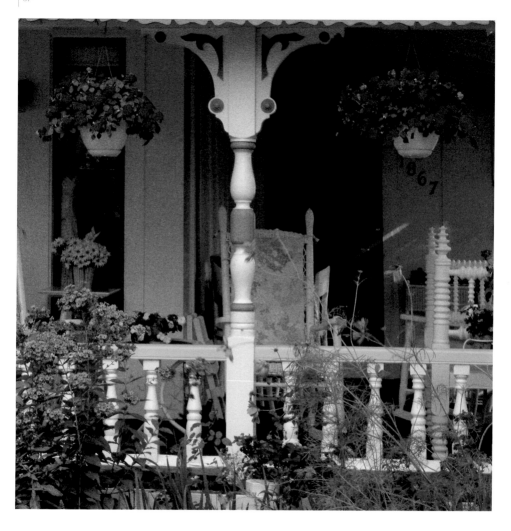

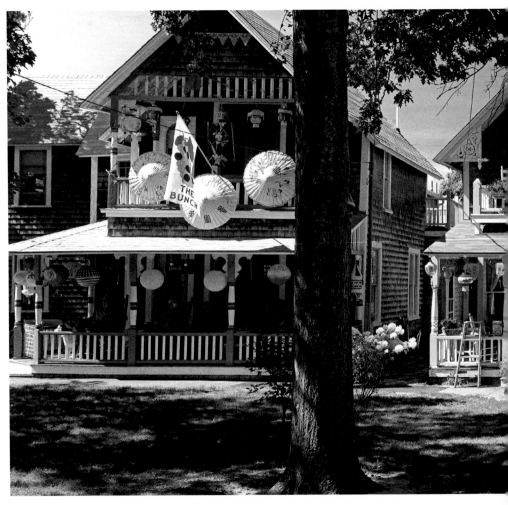

A highlight of the summer is Illumination Night.

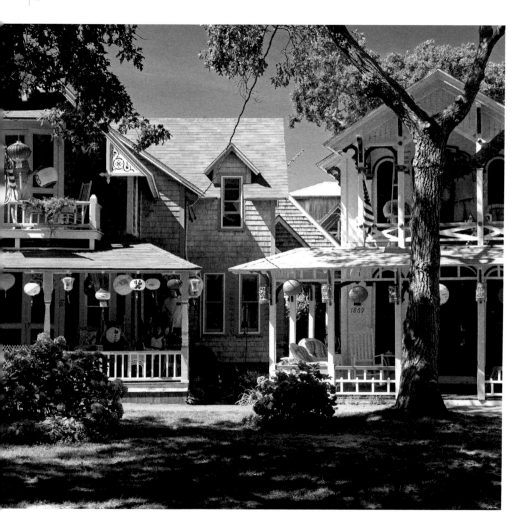

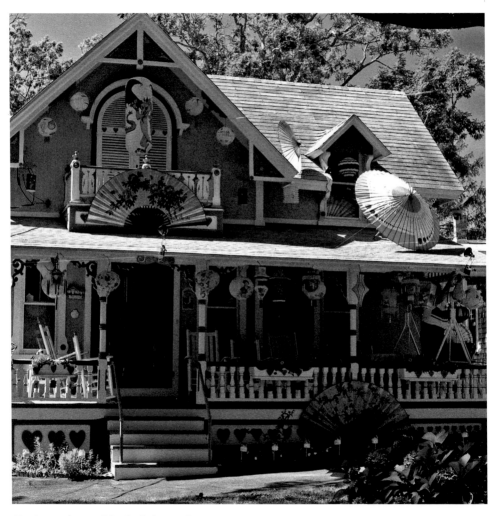

Porches are decorated for the festive evening.

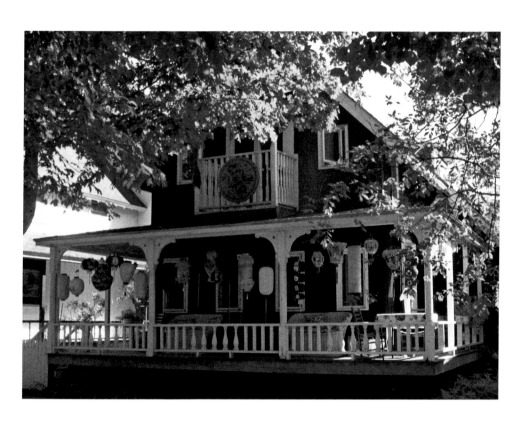

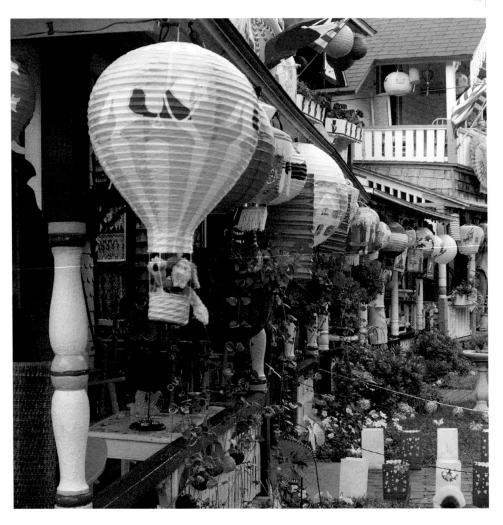

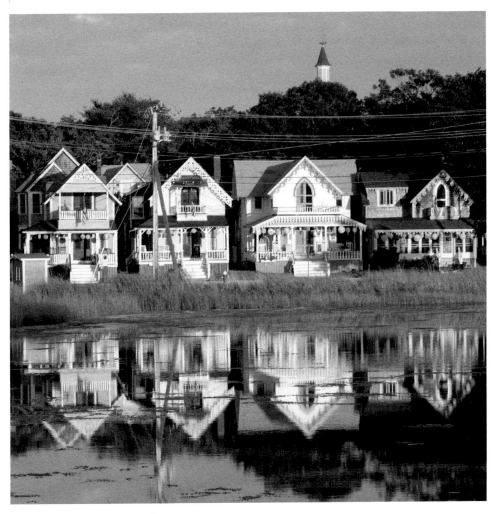

Late afternoon across Sunset Lake.

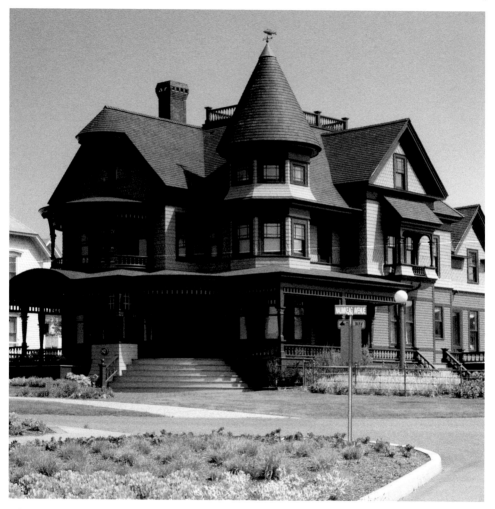

The Corbin House, beautifully restored.

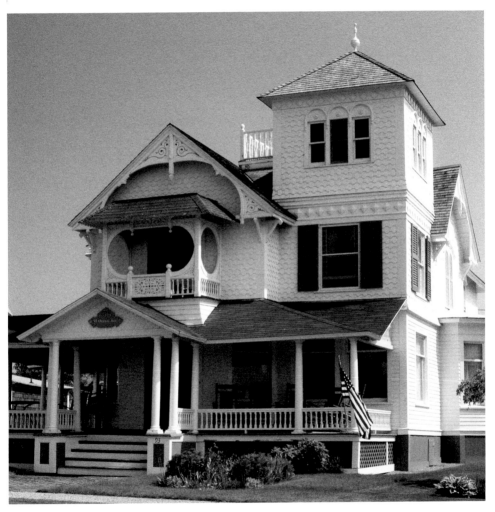

Large ornate cottages can be found near Ocean Park.

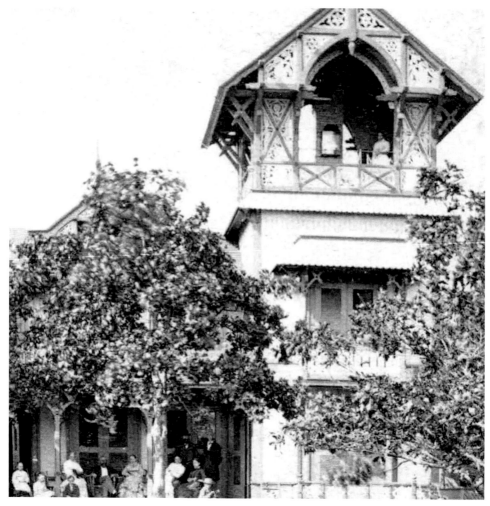

Dr. Tucker's Cottage, then . . . and now.

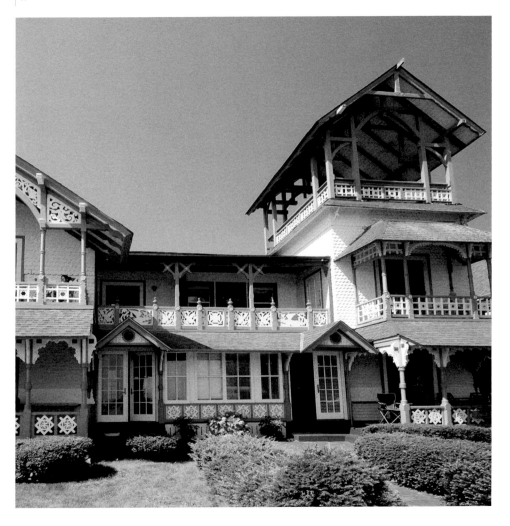

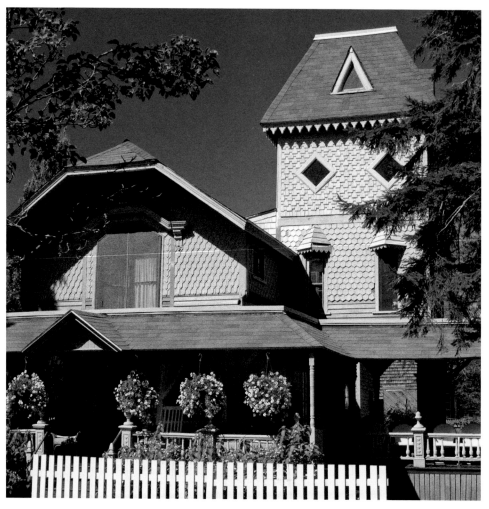

Two more magnificent restored cottages.

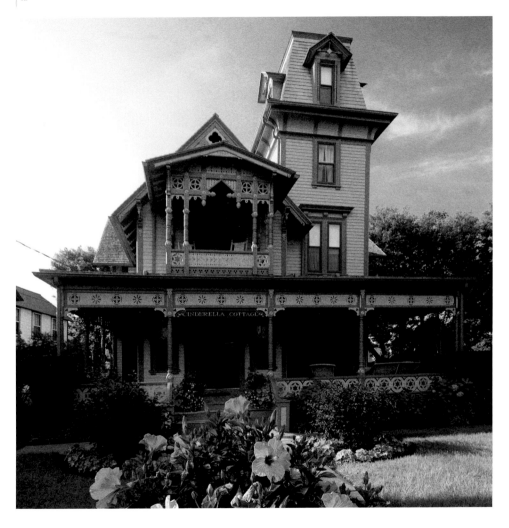

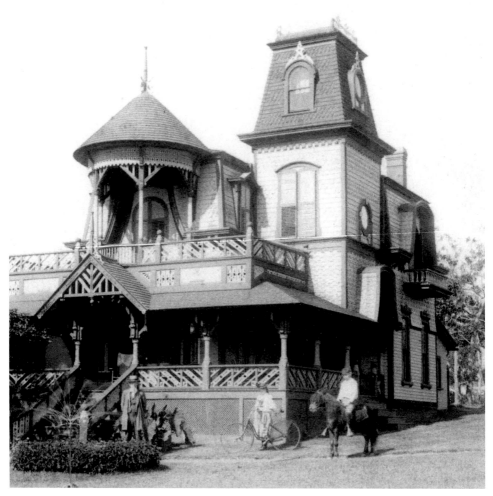

Sometimes archival images are available to compare the past and the present.

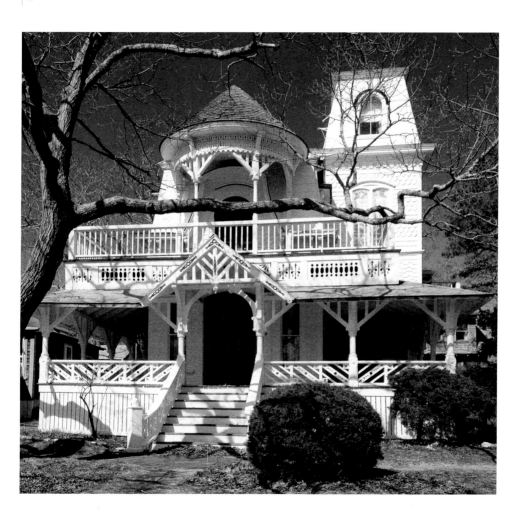

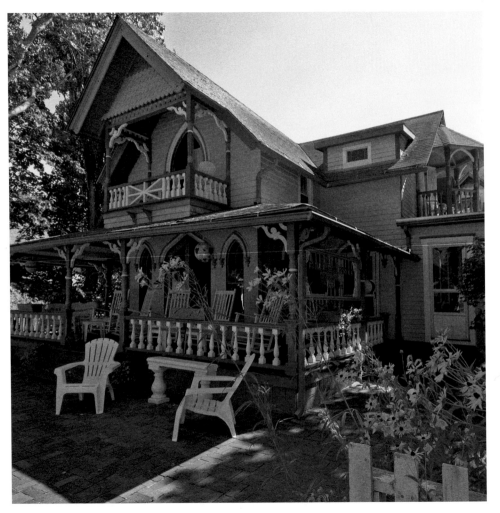

The Narragansett House is one of many inns in Oak Bluffs.

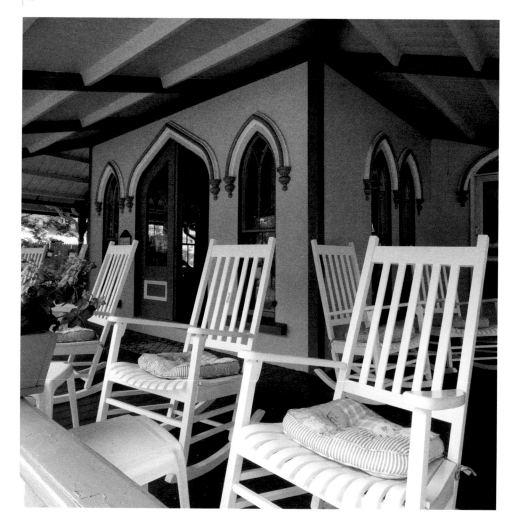

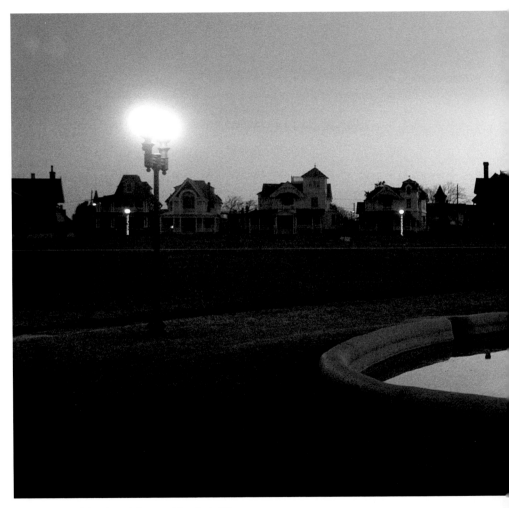

The Ocean Park bandstand decorated for the holidays.

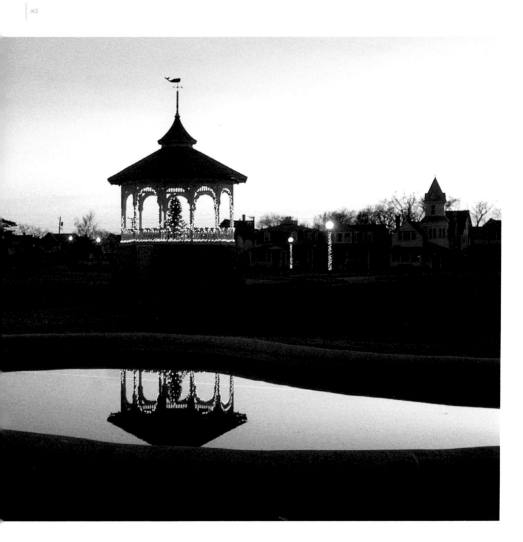

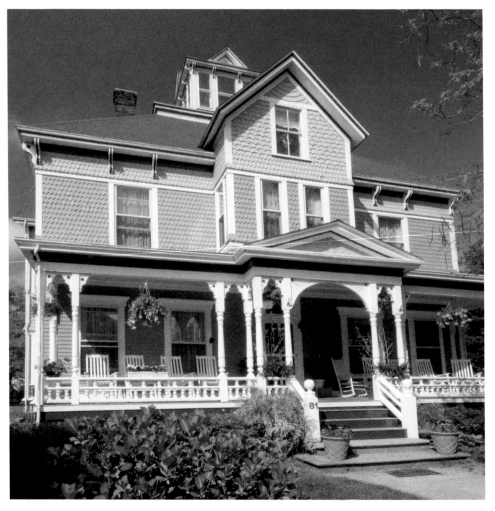

The Benbow House.

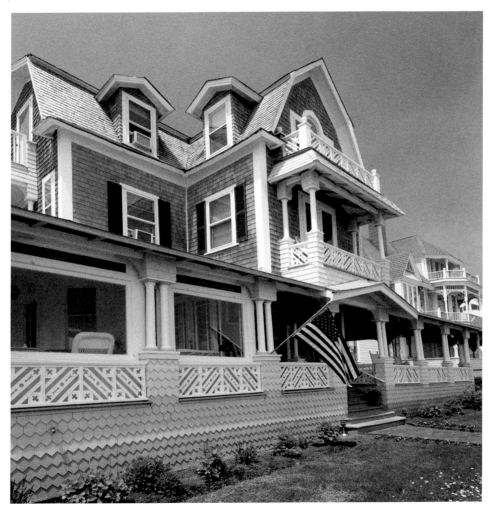

The Oak House.

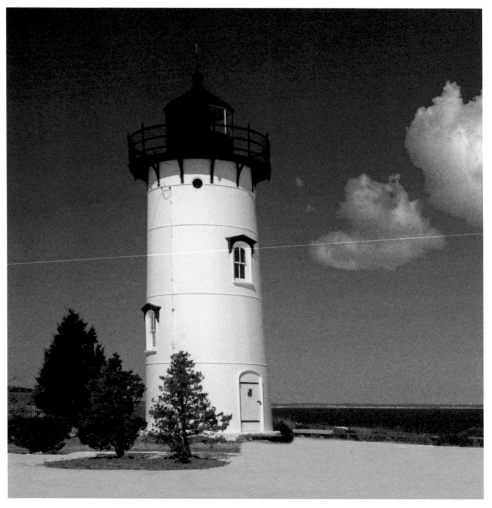

East Chop Lighthouse.

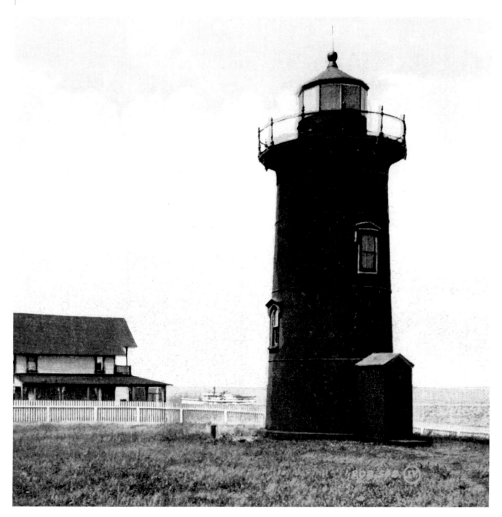

Once painted brown, it was known as the "chocolate lighthouse."

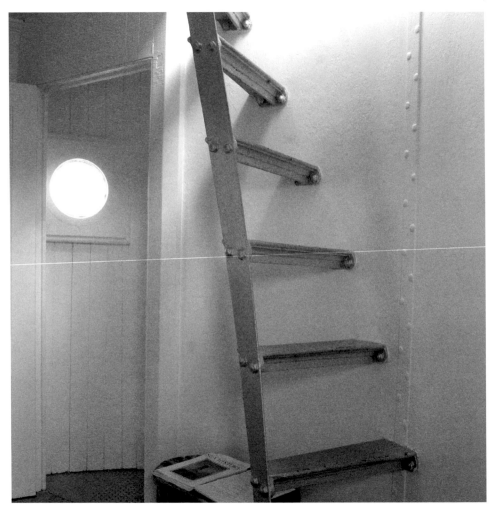

A short flight of stairs leads to the lantern room.

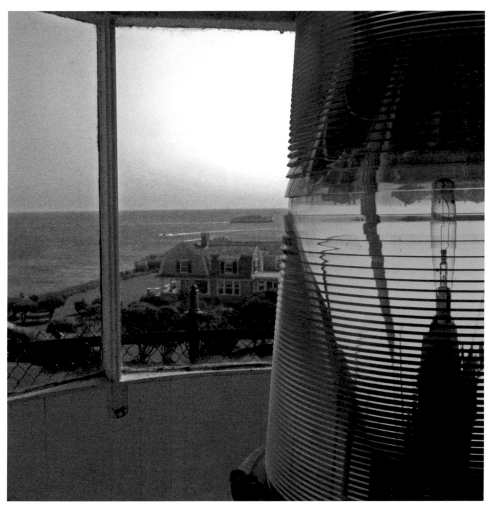

The distinctive modern green beacon.

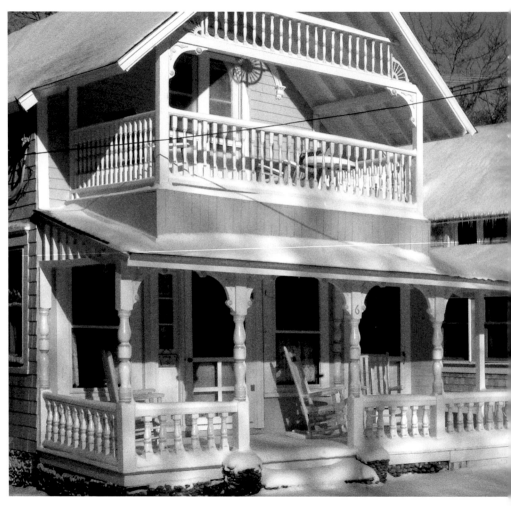

A clear winter day in the Campground.

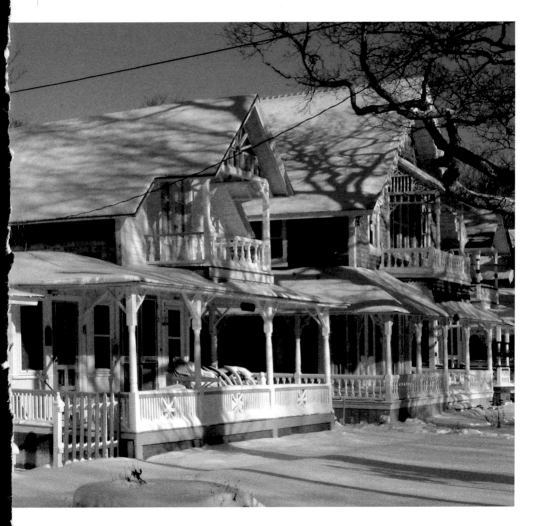

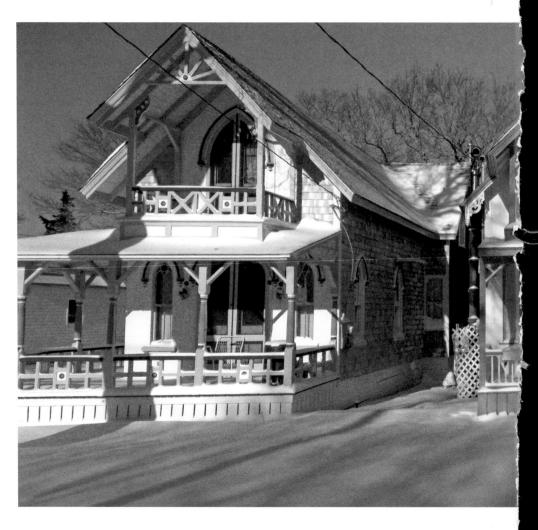

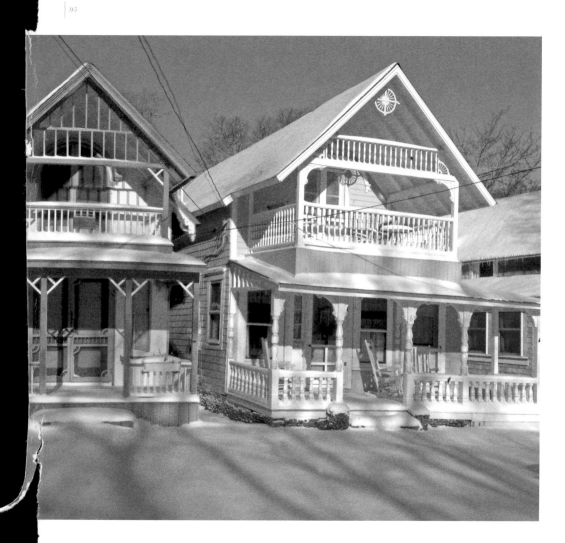

Arthur P. Richmond has been a photographer for
more than fifty years. He is the author of more
than a dozen books, and his images are also found
in calendars and postcards, as well as on
display at several galleries in Massachusetts.

Other Schiffer Books by the Author:
Boston Wide, ISBN 978-0-7643-3273-9
Massachusetts Lighthouses and Lightships,
ISBN 978-0-7643-4853-2
Harbors of Cape Cod & The Islands,
ISBN 978-0-7643-3007-0

Library of Congress Control Number: 2016938332

Designed by Molly Shields
Type set in Bell MT

ISBN: 978-0-7643 5152-5
Printed in China

Published by Schiffer Publishing, Ltd.
4880 Lower Valley Road
Atglen, PA 19310
Phone: (610) 593-1777; Fax: (610) 593-2002
E-mail: Info@schifferbooks.com
Web: www.schifferbooks.com

For our complete selection of fine books on this and related subjects, please visit our website at www.schifferbooks.com. You may also write for a free catalog.

Schiffer Publishing's titles are available at special discounts for bulk purchases for sales promotions or premiums. Special editions, including personalized covers, corporate imprints, and excerpts, can be created in large quantities for special needs. For more information, contact the publisher.

We are always looking for people to write books on new and related subjects. If you have an idea for a book, please contact us at proposals@schifferbooks.com.